PRE-RAPHAELITE
P H O T O G R A P H Y

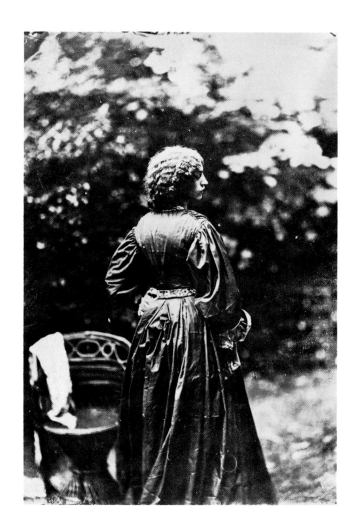

PRE-RAPHAELITE
PHOTOGRAPHY

Edited by Graham Ovenden

ACADEMY EDITIONS · LONDON
ST. MARTIN'S PRESS · NEW YORK

Acknowledgements

Thanks go to the following collectors and museums, and in particular to Mrs. St. Clair and Anthony D'Offay, for their help and permission to reproduce photographs and paintings on the following pages: Ashmolean Museum 78; Graham Bush 38; City of Birmingham Museum and Art Gallery 55, 60; Anthony D'Offay 12, 15, 30, 31, 32, 34, 45-47, 76, 79; F. Frith 71; Sir Rupert Hart-Davis 25; E. W. Huddart 40; Laing Art Gallery and Museum 33; Peter Lloyd-Jones 84; L. S. Lowry 21; Manchester City Art Gallery 42, 49; National Gallery of Canada 27; The Parrish Collection 61, 64, 65; The Royal Photographic Society 74; Mrs. St. Clair 51; The Tate Gallery 29, 36; Adrian Tillbrook 28, 35, 39; University of Kansas Museum 18; The Victoria and Albert Museum 2, 19, 20, 22-24, 26, 37, 41, 43, 75, 82, 83. The following photographs are from the collection of Graham Ovenden ; 7, 9, 11, 14, 48, 50, 52-54, 56-59, 62, 63, 66-68, 70, 73, 77, 80, 81.

Frontispiece
Mrs. William Morris posed by **Dante Gabriel Rossetti,** July, 1865.

Published in Great Britain in 1984 by
Academy Editions 7 Holland Street London W8

First edition 1972

Published in the United States of America by
St. Martin's Press 175 Fifth Avenue New York NY 10010

Printed and bound in Great Britain by
Expression Printers Ltd, London

INTRODUCTION

No school of Pre-Raphaelite Photography can be said to exist in the way that there are clearly definable photographic styles such as realism or pictorialism. But certain artists and photographers working during the mid-Victorian period are clearly linked by shared assumptions, attitudes and sentiments typical of the Pre-Raphaelite Brotherhood. Though the first flowering of the Brotherhood had but a short existence in terms of the dogmas laid down at its inauguration, with the hindsight of a passing century we can now more readily see the individual offshoots from the parent tree. The photographs here selected (and often related to paintings) clearly illustrate the pervasive influence of the Brotherhood: obviously in such photographs as H. P. Robinson's *The Lady of Shalott*, more subtly in the shared tense sensuality of Crawshay and Rossetti and the gentle humanity, rather than any mannerisms of formal composition, that links the visual styles of Hughes and 'Lewis Carroll', Charles Lutwidge Dodgson.

The evolution of art and technology throughout history has resulted in a paradox which reached a point of incompatibility during the nineteenth century and virtual spiritual annihilation during the twentieth. The delight in the enlargement of nature's prism by the technological advance of fixing her image by chemical action and the consequent broadening of man's understanding of his universe led almost simultaneously to a surfeit in our reaction to human intolerance. It is as if the ability of man to 'improve' his material being must inevitably lead to the destruction of his awareness to fundamental truth. Yet man must first raise himself above the level of mere physical existence before he can allow the mind the simple necessity of art, which, however indulgent it has seemed within its epoch, stands apart and stabilizes the excess of human action.

It is these extremes of direction, from the bejewelled truth of Ruskin's 'nature' and the ennobling of man through work to the squalid reality of industrialization that give such moment and pathos to much of the visual and aural arts during the nineteenth century. Art as a vehicle to reveal human injustice (at its finest in the social novel) is an important facet of the Victorian attitude to art. But there is an equal desire to understand the nature of man's pastoral environment, the unseen mystic emphasized as greatly as the visually seductive. And it is possibly this gentle attitude towards nature and towards the profound human relationship of love that has led our age to accusations of a basic weakness in the Victorian's grasp of reality. The truth is that we confuse sentiment with sentimentality, confidence with egotism. We have been corrupted by the neurosis of innovation and materialism as an end in

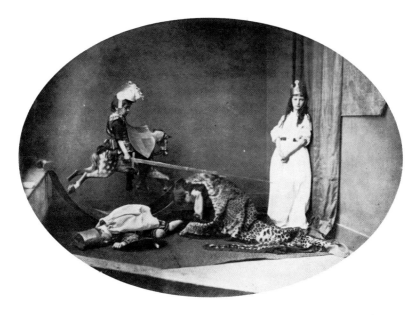

C. L. Dodgson: *St. George and the Dragon*, c 1874. (Author's collection)

itself, a neurosis first spawned in the age of industrialization which at first, however, did not totally ensnare mankind.

The very nature of the photographic image must ally it to certain of Ruskin's dogmas. For although a photograph is no less an interpretation of the physical than a painting of sculpture, its uncanny precision, recording all within its compass with equal fidelity, reveals that which the eye often neglects. In Ruskin, whose vision was based not only on a profound understanding of the inherent poetry of the universe but also on a scientific knowledge of the various materials of the natural world, we see the basic strength of the Pre-Raphaelite art. That all nature, however insignificant, is possessed of a certain dignity; that a true visual statement is an act of worship and equally applicable to the inanimate; that the emotive qualities of love between man and woman, adult and child must be understood.

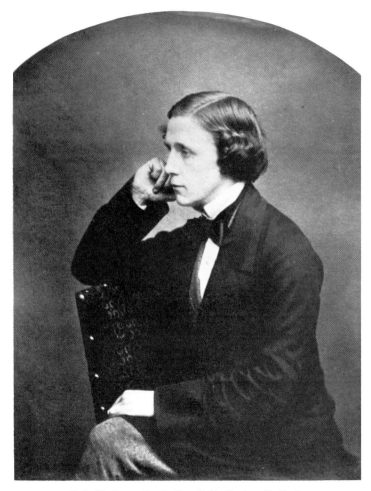

C. L. Dodgson: Lewis Carroll.(Author's collection)

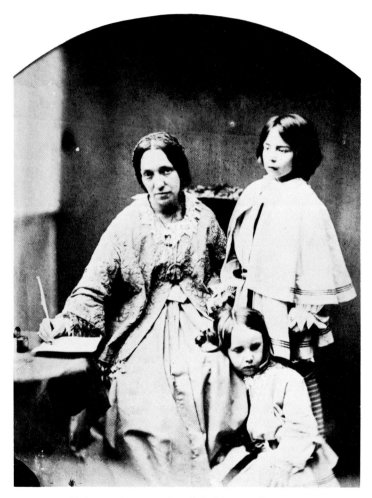

Unknown Photographer: Julia Margaret Cameron.

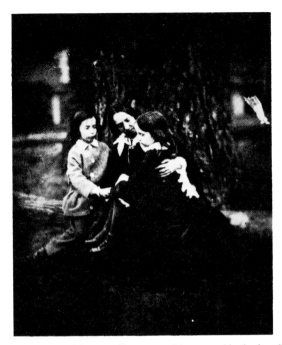

C. L. Dodgson: Julia Margaret Cameron and her sons. (Author's collection)

If Millais and Hunt at their finest show the virtues of Ruskin's teaching, Rossetti displays little sympathy for nature's mirror. He concentrates primarily on unconsummated or guilty, though nevertheless deeply religious love. There is some parallel in the hopeless adoration by Rossetti of Jane Morris with Dodgson's love for Alice Liddell. The work of each produces the sensation of a distant sorrow, an inward containment, which though we sense it we cannot share. Even in Millais, who of all the Pre-Raphaelites remained the charming extrovert, there is that sense of melancholy verging on despair. *Autumn Leaves*, amongst the greatest of nineteenth-century painting, is a work filled with sadness, and the loneliness of the dying landscape seems only to accentuate the ravishing beauty of the children.

Dodgson, whose technical accomplishments in drawing were of the slightest, seldom approached such an intense sensual poetry in his sketches, but in the camera, the technical difficulties of representation being removed, he found the medium through which he was visually able to communicate. One is not correct in looking at Dodgson's photography as solely a record of a pleasant afternoon or as an emotional substitute for the child he could never possess. Dodgson's photographic work is a gentle but profound comment upon the fleeting moments of that precious time of transience between the reality and dreams of childhood. Though Alice is tangible enough, she remains aloof and we are unable to enter that peculiarly unprejudiced sense of the world that these little beings radiate. Dodgson's children are enclosed in their own private existence; we are allowed to see a final image but in seeing there is almost a sense of intrusion. One feels that there is some deep intensity of rapport between the precise mathematics lecturer and the child that was theirs alone; a precious moment of time that, by a chemical reaction, became frozen for posterity. But also, there is a profound sense of human love in the finest of Dodgson's images, we understand the man more because of them. What in many of us may be a sentimenal attachment to a child has, in Dodgson, become through sorrow and religious honesty the unwavering conviction of truth.

Though Dodgson seldom left us the powerful imagery of the great Victorians so ably achieved by Mrs. Cameron, he occasionally produced masterpieces in this genre conceived in a totally personal manner. Unlike Mrs. Cameron's, his sitters do not stare into the lens, we do not see under the mask, but in such a litle jewel as Alexander Munro and his wife, humanity is self-contained as in Rembrandt's great *Jewish Bride*. Love is present with no need of worldly confidence.

Dodgson was undoubtedly formally conversant with the aims of certain Pre-Raphaelite painters but the one to whom he was most akin was Arthur Hughes. Dodgson owned Hughes' painting *The Lady of the Lilacs* (not by any means a Hughes masterpiece) and the two men were close in sentiment, as the photograph by Dodgson of the artist and his daughter so readily conveys, a similar gentle sweetness and melancholy pervading the work of both photographer and painter. Like Millais, Hughes possessed a great feeling for the textural qualities of fabrics, something that concerned Dodgson equally. In his diaries, there are numerous entries relating to the type of dress to be worn by his sitters and, as with the painters, a very definite preference for the simpler, proletarian materials.

The subtle nastiness which introduces so often in his writing is seldom found in Dodgson's photographic work. One looks in vain for the violence, the Queen's hysterical shriek 'off with his head', that awes us in the Alice books.

Even in the photograph of *St. George and The Dragon*, the action is unconvincing, Xie

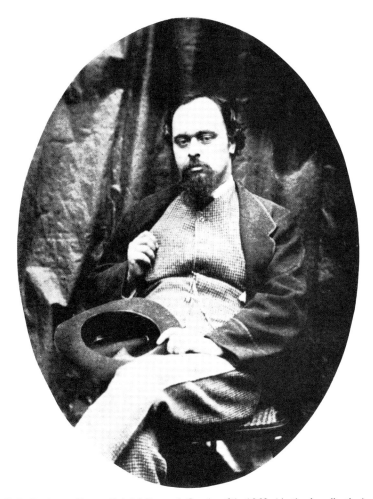

C. L. Dodgson: Dante Gabriel Rossetti, October 6th, 1863. (Author's collection)

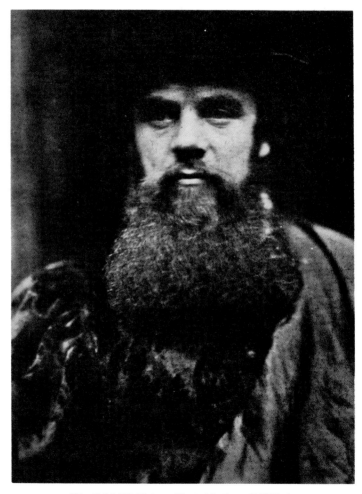

Wynfield: W. Holman Hunt. (Anthony D'Offay)

Kitchin stands utterly unperturbed by the events. More convincing is the excursion into the world of fantasy of *The Dream*. Over and above the obvious connections with spirit photography there is that sense of the ethereal, shared equally by Hughes, so dear to the Victorian appetite for the Gothic and the unseen.

Such a photograph shows us even if frivolously the limitations of the photographic medium. If one studies the extremely beautiful rendering by Rossetti of *The Wedding of St. George and Princess Sabra* one is immediately aware of the sincerity of conviction with which paint can communicate a mediaeval romance. Mrs. Cameron's rendering in her photographic illustrations for Tennyson's *The Idylls of the King*, is more successful than Dodgson's amateur theatricals, but still has a mawkish air. It would seem that the more the photograph image is made to play the part of the imitator of a painting, the further removed from art are the results. There is an inherent surrealism in virtually any photographic image which, if sufficiently brought to the fore by any sensible operator will lift a mere pictorial record into the realm of art. This is not to say that technical oddities are sufficient to maintain a continuous vocabulary of communication. The final analysis, as in painting, relies on the sensibility of the manipulator.

Mrs. Cameron, as Dodgson, created great works of portraiture not merely because of their photographic eccentricities but through a basic love of humanity and the intense desire to externalize their emotion visually. Neither was sufficiently practised in the traditional academic forms of representation so each took to the camera as the most ready means of communication. Perhaps it was fortunate that the actual manipulation necessary in producing a photograph during the wet collodion period was so fraught with difficulties, as there is very little sense of the casual in their finest photographs. Julia Margaret Cameron in particular seems to have instinctively understood the nature of the camera image, the long staring into the lens that induces such gravity in the final picture. Certainly there is no formal portraiture in Victorian art that arouses such compelling sympathy in the spectator as her photographs of Tennyson, Herschel or Mrs. Duckworth.

If the influence of the Pre-Raphaelite painters' search for realism contradicts Mrs. Cameron's sense of spiritual romanticism, it is because the camera is unable to interpret as readily as paint the complex emotional strain that make up the strength and weakness of mid nineteenth-century English art. Often, but not inevitably, the sublime hovers on the brink of the absurd. Certain images by Mrs. Cameron give greater depths to our understanding of the languid sensuality of ideal Victorian womanhood. As in Rossetti's photographs of Jane Morris, we understand more about the age and its aspirations. Jane was inspiration after the death of Lizzie Siddal and we see in Jane's photographic likenesses that the Pre-Raphaelite image of women was based on a living being, not on the fantasy of a decaying, dope-ridden

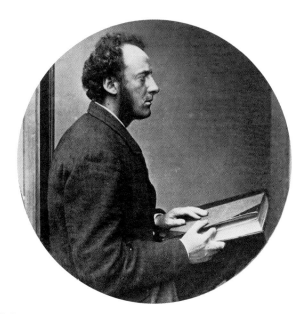

C. L. Dodgson: John E. Millais, July 21st, 1865. (Author's collection)

mind. Equally, many of Mrs. Cameron's women sitters exclude a certain aura of inward conviction of the spirituality of existence and we can forgive the many excesses of her art. Over and above the theatricals there is a true sense of being.

If Mrs. Cameron can be said to possess one great weakness, it is her inability to compose structurally groups of figures. There tends to be a general air of confusion rather as if the sitters were jostling for the best position and the lens' cap removed before the final position is concrete. A comparison with Dodgson accentuates Mrs. Cameron's shortcomings, for no photographer possessed a greater ability in creating a genuine sense of unity and sympathy between individuals than the Oxford mathematician. There are charming surprises, however, in Mrs. Cameron and it is, perhaps, her innocence of the absurd that gives such a lively quality to the picture *Blackberry Gathering* with Florence Anson peering from the margin.

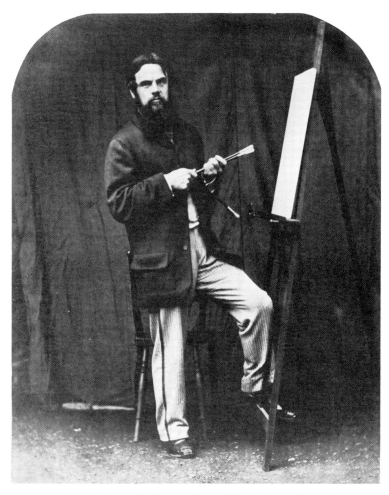

C. L. Dodgson: W. Holman Hunt, 1864. (Anthony D'Offay)

15

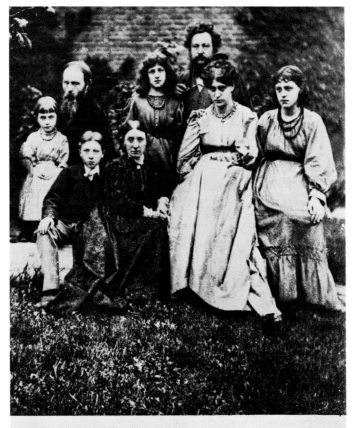

The Burne-Jones and Morris families
Photographed at the Grange in 1874
by Frederick Hollyer

The extremes of temperament, the aggressive assurance of Mrs. Cameron to the shy, retiring nature of Dodgson, is seen most clearly in their handling of children. Dodgson's art is that of unobtrusive restraint. What tension exists is latent and sensual. Mrs. Cameron instills in her little sitters the need for servility. But how unending must an exposure of between three and seven minutes have seemed to a child. Their faces show at best a puzzled questioning and, at times, a mood of downright agitation. Dauntlessly Mrs. Cameron exposed plate after plate and how can we but admire an intellectual member of an elite society taking up photography at the age of forty-eight and devoting her days to the 'black art'. When all the absurdity and anguish in the creation of the plates are forgotten, the prints remain, staring at us albeit reproachfully but nevertheless enriching our understanding of humanity.

The element most obviously lacking in both Dodgson's and Cameron's work is that of nature as an expressive means in itself. The intrusion of foliage in such a photograph as in *In the Garden* is incidental and serves only as a decorative foil. Landscape as used by Millais in *Autumn Leaves* or Maddox Brown in *An English Autumn Afternoon* becomes of equal importance as the souls that inhabit it. Inchbold under Ruskin's tutelage dispenses totally with man, painting one of the most lovely of English landscapes completely unfettered by stylistic shibboleths. This freshness of vision is often present in English landscape photography during the sixties and a print like Henry White's *Bramble and Ivy* has the similar jewel-like quality of Millais and Hughes' rendering of foliage. Needless to say, the photographic image lacks that intensity of colour which is one of the most startling elements in Pre-Raphaelite painting but the sentiment of the nobility of simple things that pervades White's photography harks back to Ruskin's 'truth to nature.'

Bedford also possesses this quality and the soft, caressing tone of his prints, the simple, unassuming nature of pastoral life is seldom battered in Victorian photography. Bedford's photographs illustrate what is perhaps one of the most potent qualities in Pre-Raphaelite art, the harmonious existence of the natural and human world. Admittedly, if one walks from Brown's Hampstead into Whitechapel the discord and inhumanity becomes appalling and we can only weep for the blind child who lived a life of misery in such conditions instead of sitting sightless but seeing in a radiant, rainbowed landscape. Perhaps the first joy of discovery is the most precious in men's formative being. The sense of wonder aroused by the minuteness of nature suffused by the poetry of light is shared by the works of Van Eyck, the first Pre-Raphaelite masterpieces and early photography. Each is equally a realization of a facet of an infinite visual language, whether inspired by technical innovation or the awakening eye.

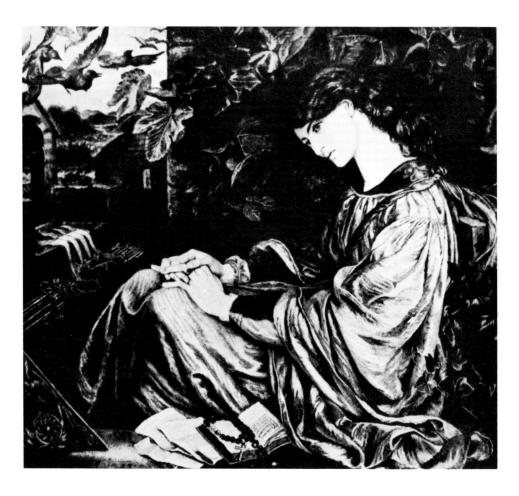

D. G. Rossetti: *La Pia de' Tolomei*, oil 41½ x 47½ in., 1868-80. (University of Kansas Museum)

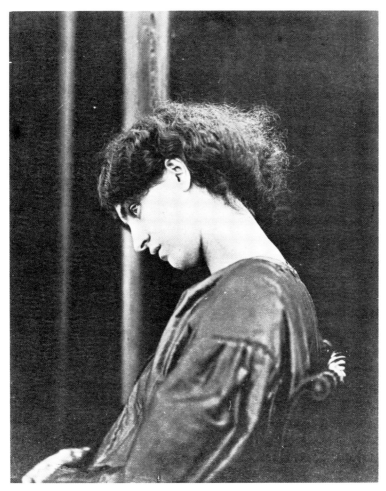

Jane Morris posed by **D. G. Rossetti**, 1865.

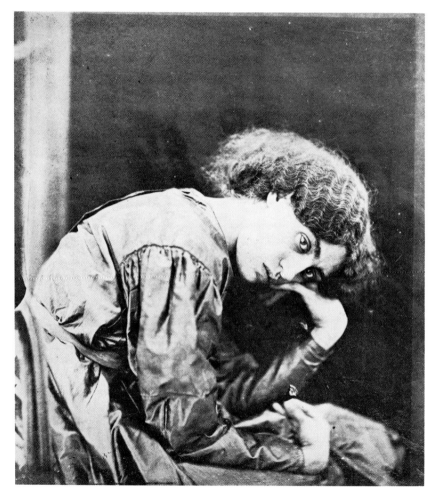

Jane Morris posed by **D. G. Rossetti**, 1865.

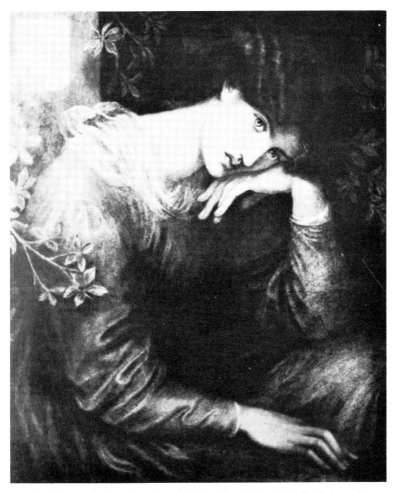

D. G. Rossetti: *Reverie*, coloured chalks, 33 x 28 in., 1868. (L. S. Lowry)

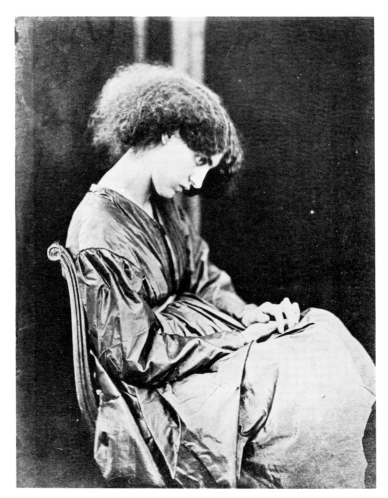

Jane Morris posed by **D. G. Rossetti**, 1865.

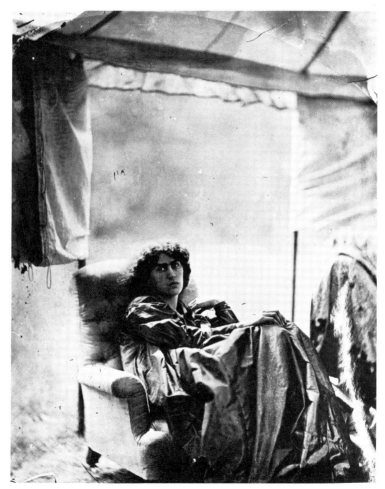

Jane Morris posed by **D. G. Rossetti**, 1865.

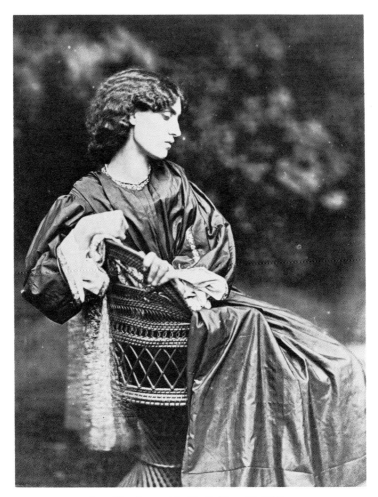

Jane Morris posed by **D. G. Rossetti**, 1865.

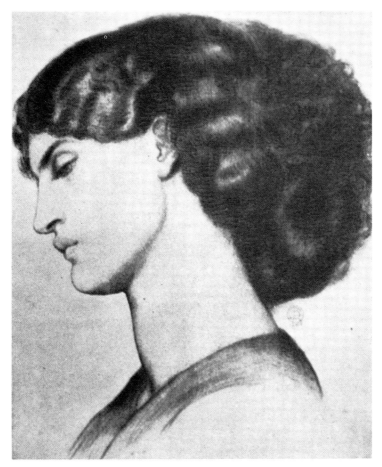

D. G. Rossetti: Jane Morris, black chalk, 16½ x 13½ in., 1865. (Sir Rupert Hart-Davis)
This drawing admirably shows the subtle elongation of the neck apparent in so many of Rossetti's portraits of Jane Morris.

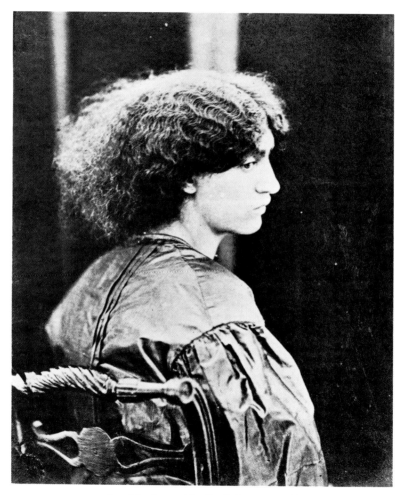

Jane Morris posed by **D. G. Rossetti**, 1865.

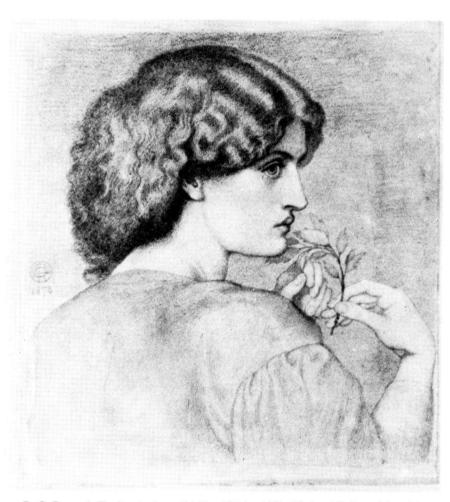

D. G. Rossetti: *The Roseleaf*, pencil 14¼ x 13¾ in., 1870. (National Gallery of Canada)

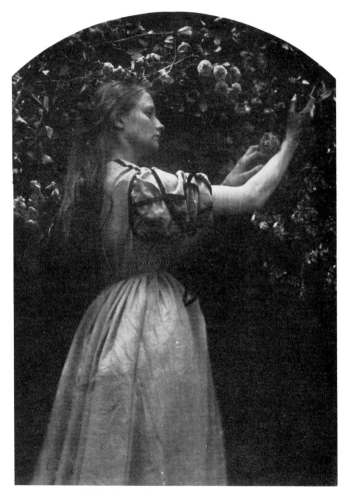

J. M. Cameron: *In The Garden*, c 1870.

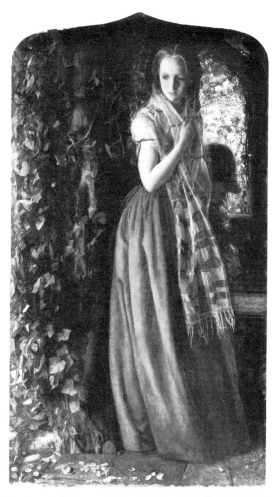

Arthur Hughes: *April Love,* oil 35 x 19½ in., 1855-6. (The Tate Gallery)

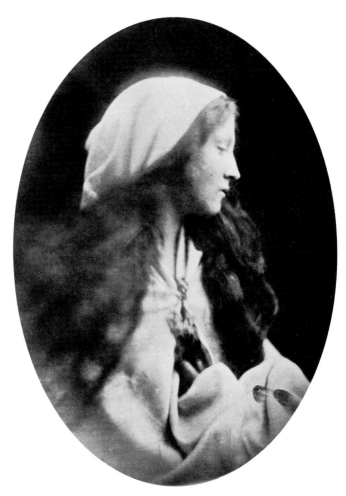

J. M. Cameron: *The Day Dream*, 1869.

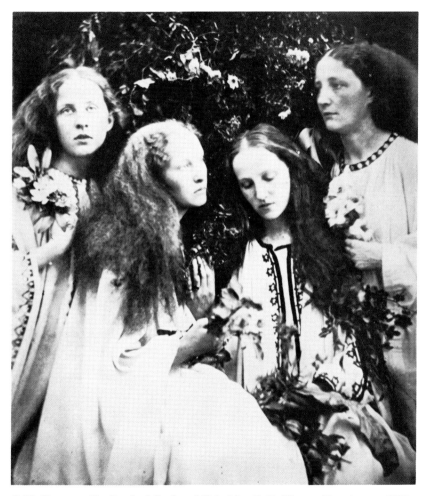

J. M. Cameron: *The Rosebud Garden of Girls*, Mrs. G. F. Watts and her sisters, c 1870.

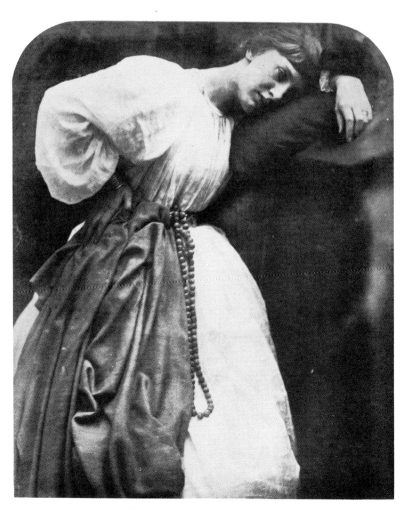

J. M. Cameron: May Prinsep, c 1870.

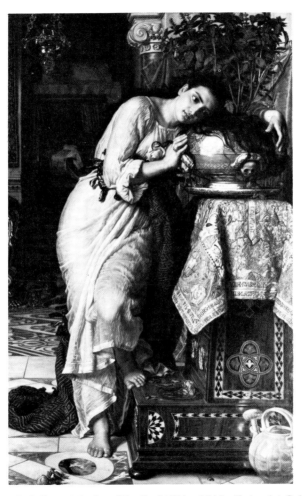

W. Holman Hunt: *Isabella and the Pot of Basil,* oil 72½ x 44½ in. (Laing Art Gallery and Museum)

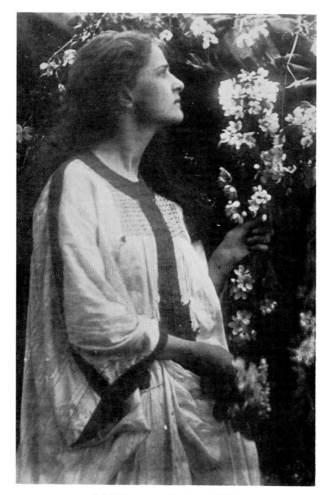

J. M. Cameron: *Spring*, c 1870.

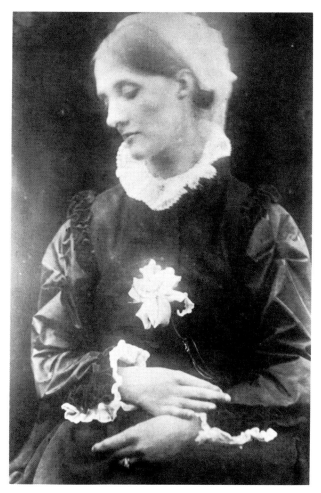

J. M. Cameron: Mrs. Herbert Duckworth (Mrs. Leslie Stephen), 1872.

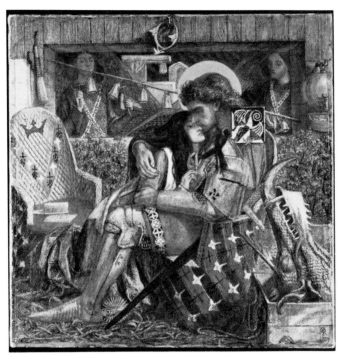

D. G. Rossetti: *The Wedding of St. George and Princess Sabra,* watercolour 13 x 13 in., 1857.
(The Tate Gallery)

Though Rossetti most profoundly identified with the early Italian Renaissance poet Dante, his sense of English mediaevalism is the most authentic of all the Pre-Raphaelites. Whereas Holman Hunt rarely progresses beyond the mannered stage set, in Rossetti there is a unity of form and sentiment that goes far beyond the average historical painting of the nineteenth century. Mrs. Cameron more often than not failed in her costume illustrations for Tennyson's *Idylls of the King* but in *Guinevere and Lancelot* there is a genuine sense of grief that surmounts the usual photographic inadequacies.

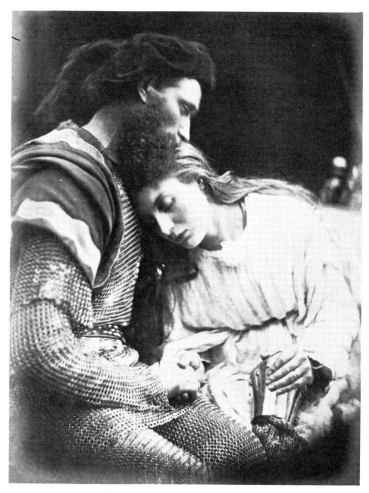

J. M. Cameron: *The Parting of Sir Lancelot and Queen Guinevere*, The Idylls of the King, 1875.

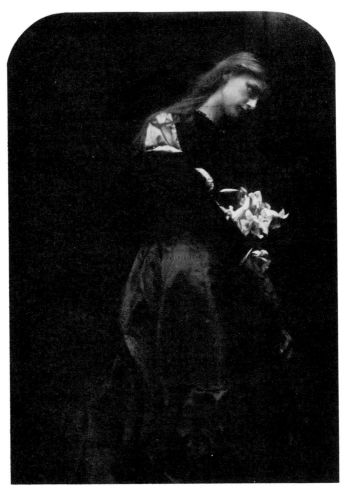

J. M. Cameron: *Gretchen*, 1870.

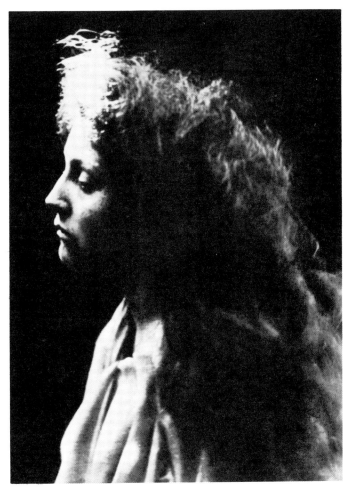

J. M. Cameron: *The Angel at the Tomb*, (Mary Hillier), c 1872.

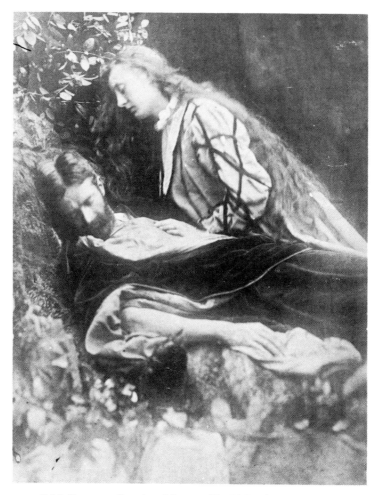

J. M. Cameron: *Gareth and Lynette*, The Idylls of the King, 1875.

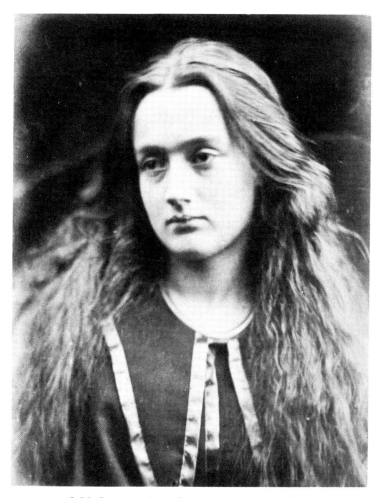

J. M. Cameron: Annie Cameron, November, 1869.

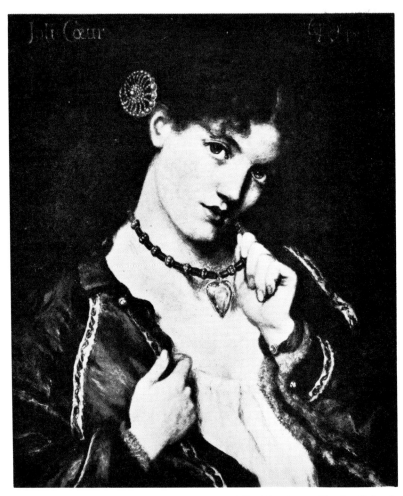

D. G. Rossetti: *Joli Coeur*, oil 14¾ x 11¾ in., 1867. (Manchester City Art Gallery)

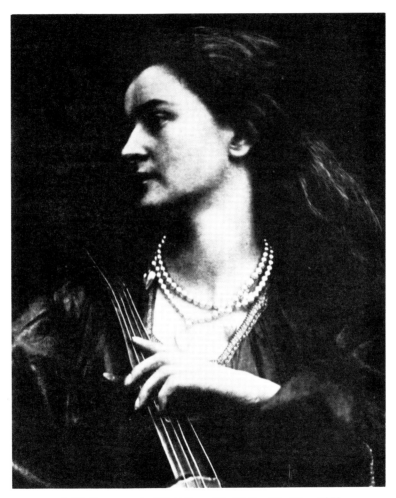

J. M. Cameron: *And Enid Sang*, The Idylls of the King, 1875.

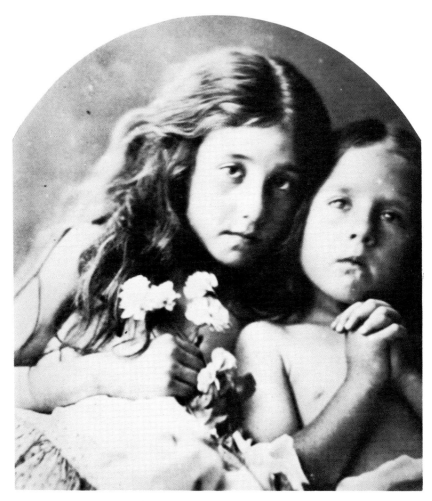

J. M. Cameron: *Red and White Roses*, c 1865.

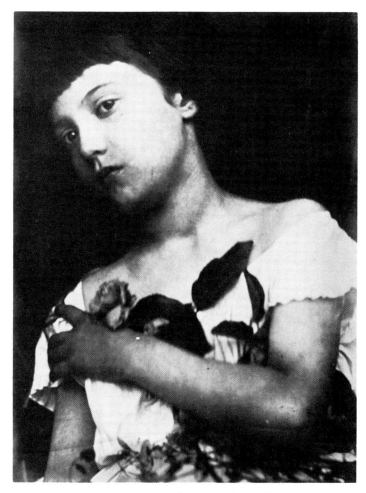

J. M. Cameron: Florence Fisher, 1872.

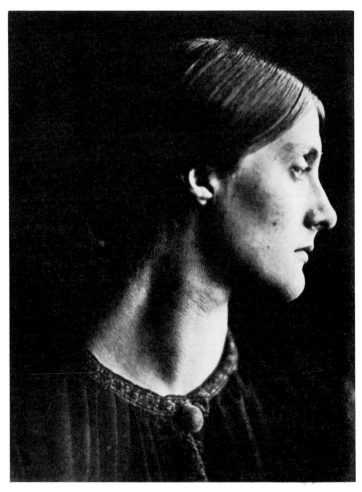

J. M. Cameron: Mrs. Herbert Duckworth, 1868.

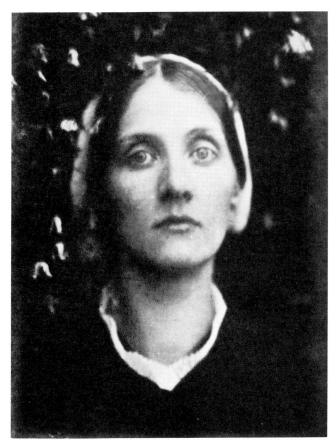

J.M. Cameron: Mrs. Herbert Duckworth, 1868.
Julia Jackson, who subsequently married Leslie Stephen, was the mother of Virginia Woolf.

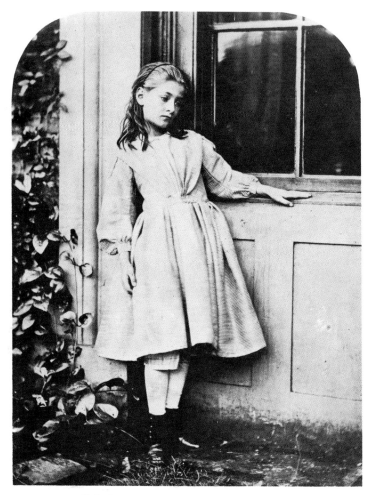

C. L. Dodgson: Gertrude Dykes, October, 1862.

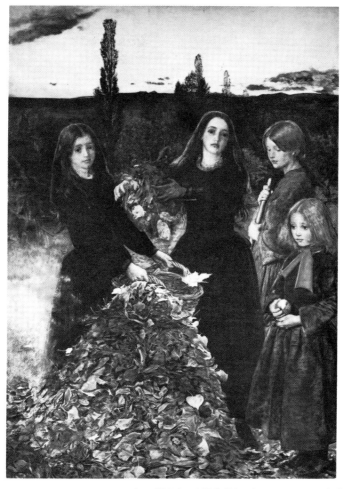

J. E. Millais: *Autumn Leaves,* oil 41 x 29½ in., 1856. (Manchester City Art Gallery)

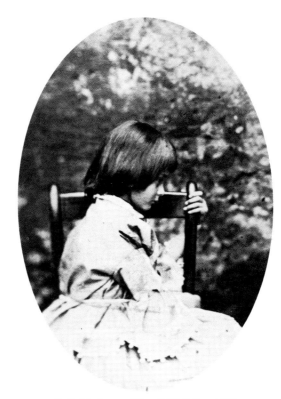

C. L. Dodgson: Alice P. Liddell, c 1858.

Alice Pleasance Liddell (Mrs. Reginald Hargreaves) was the second daughter of Henry George Liddell Dean of Christ Church and Vice Chancellor of Oxford University. It was on July 4th, 1862, that Dodgson, the three Liddell sisters and R. Duckworth made the eventful trip up the Isis that resulted in Dodgson extemporising the story of *Alice's Adventures Underground* which was later to develop into *Alice's Adventures in Wonderland.*

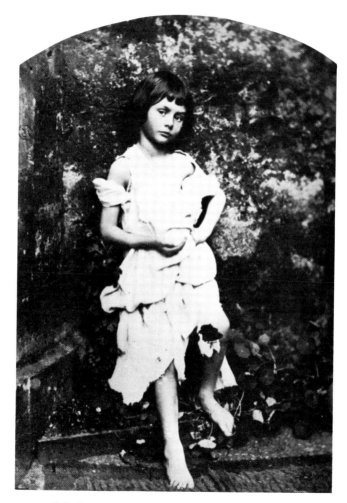

C. L. Dodgson: Alice Liddell as a beggar girl, c 1859.

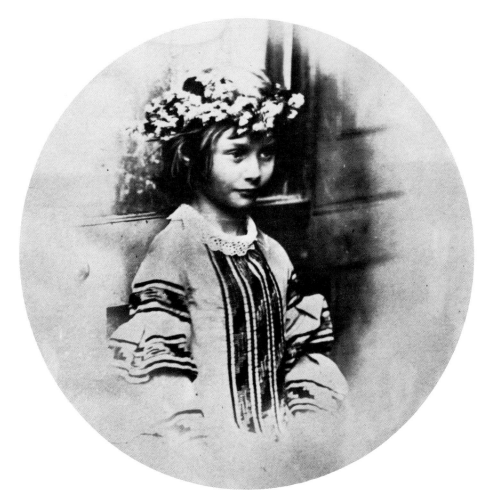

C. L. Dodgson: Alice P. Liddell, c 1859.

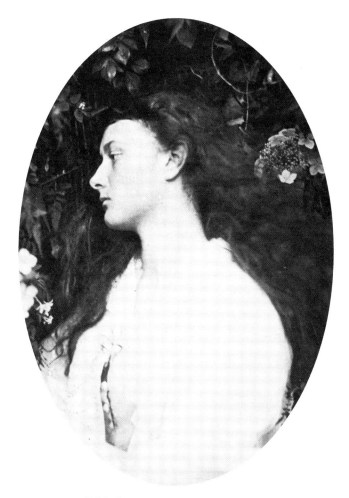

J. M. Cameron: Alice P. Liddell, 1872.

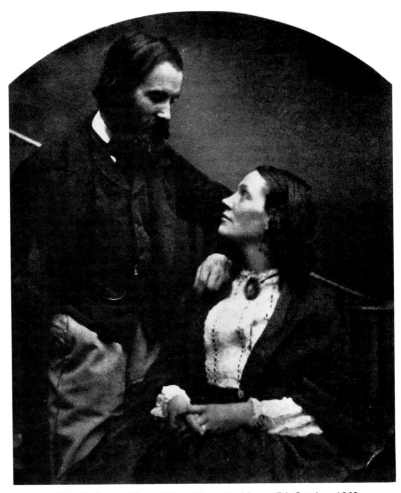

C. L. Dodgson: Mr. and Mrs. Alexander Munro, 7th October, 1863.

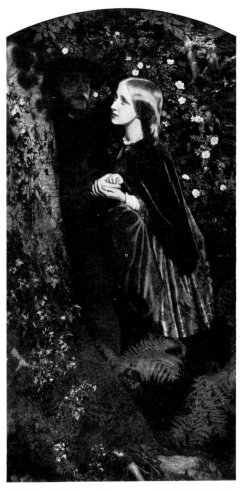

Arthur Hughes: *The Long Engagement,* oil 41½ x 20½ in., 1859.
(City of Birmingham Museum and Art Gallery)

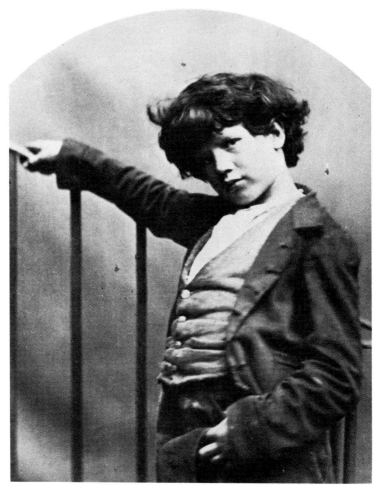

C. L. Dodgson: *The Milkman's Boy*, Angus Douglas, 7th October, 1863. Douglas was one of Rossetti's models.

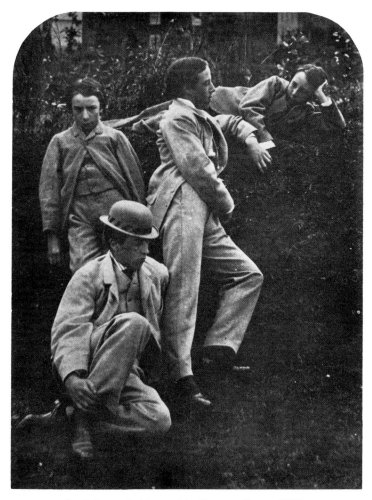

Lord Somers?: Group of the Cameron Boys, c 1865.

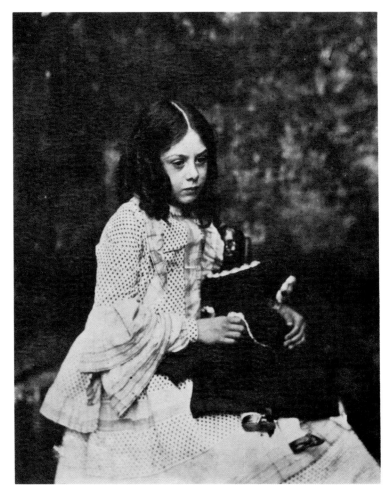

C. L. Dodgson: Lorina Charlotte Liddell, 1858-9.

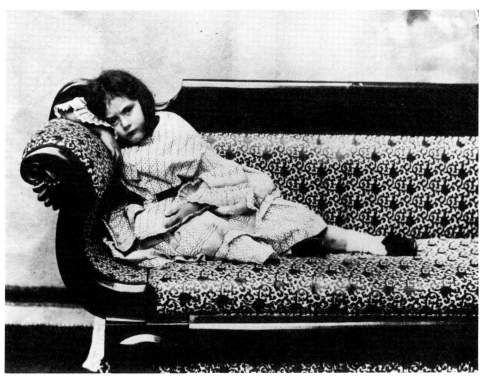

C. L. Dodgson: Lorina Charlotte Liddell, 1858-9.
Lorina was the eldest daughter of Henry George Liddell.

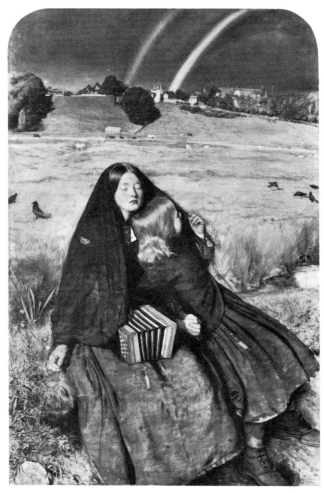

J. E. Millais: *The Blind Girl*, oil 32½ x 24½ in., 1856. (City of Birmingham Museum and Art Gallery)

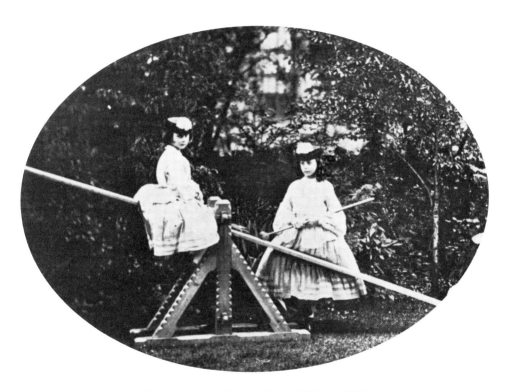

C. L. Dodgson: Alice and Lorina Liddell, c 1858.

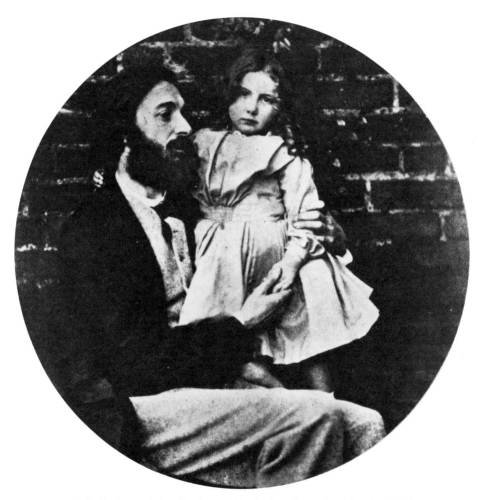

C. L. Dodgson: Arthur Hughes and his daughter Agnes, 12th October, 1863.

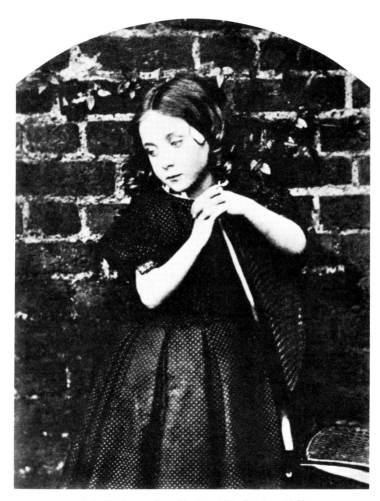

C. L. Dodgson: Amy Hughes, 12th October, 1863.

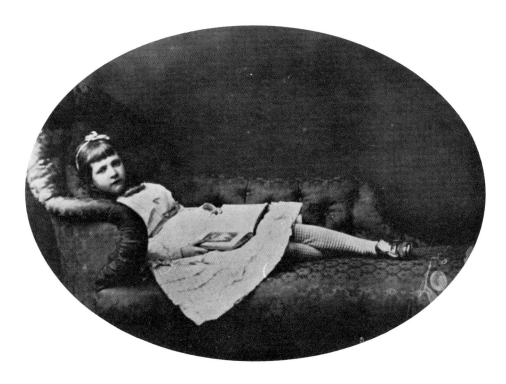

C. L. Dodgson: Alexandra (Xie) Kitchin, 1873.

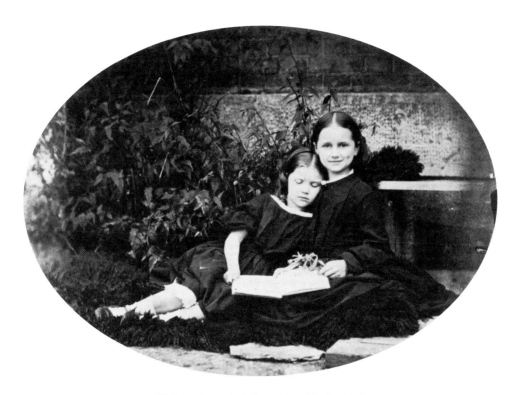

C. L. Dodgson: Ethel and Lilian Brodie, 1862.

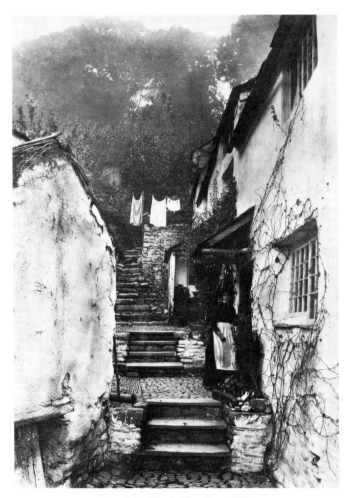

Francis Bedford: Clovelly, c 1870.

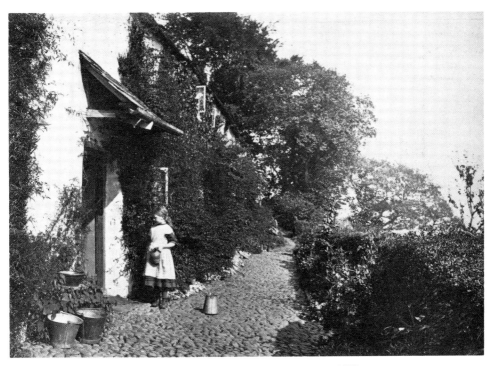

Francis Bedford: Clovelly, Mount Pleasant, c 1870.

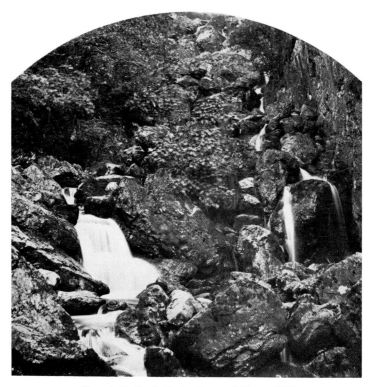

Francis Bedford: Study of water falling, c 1870.

Ruskin discovered the new photographic art during the spring of 1840. He records in *Praeteria* 'it must have been during my last days at Oxford that Mr. Liddell, the present Dean of Christ Church, told me of the original experiments of Daguerre. My Parisian friends obtained for me the best examples of his results; and the plates sent to me in Oxford were certainly the finest examples of the sun's drawings that were ever seen in Oxford, and, I believe, in England'.

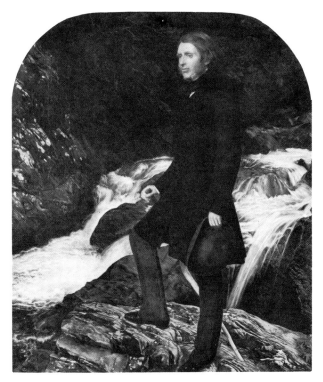

J. E. Millais: *John Ruskin*, oil 31 x 26¾ in., 1854. (The Royal Academy)

Ruskin in fact made use of the process and though he states that he did not use daguerreotypes in preparing the mezzotints contained in *Examples of the Architecture of Venice* (1851), he proceeds to say 'I much regret that Artists in general do not think it worth their while to perpetuate some of the beautiful effects which the daguerreotype alone can seize'.

Henry White: *Bramble and Ivy*, 1860.

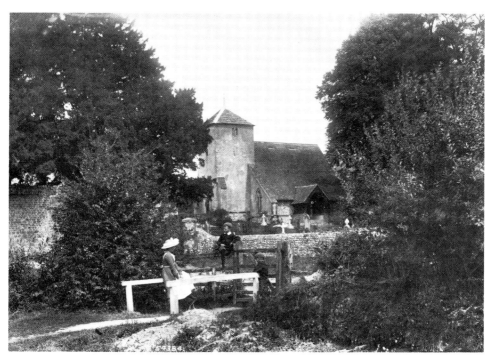

F. Frith: Cocking Church.

Francis Bedford: *Summer*, c 1870.

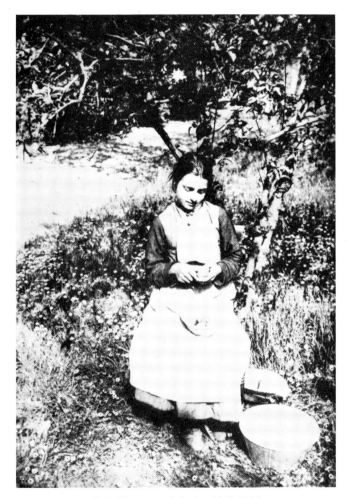

Peter Emerson: *A Spring Idyll*, 1886.

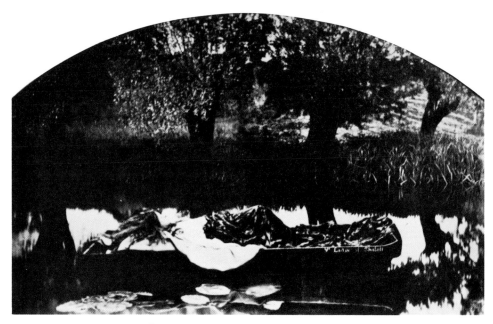

H. P. Robinson: *The Lady of Shalott*, 1861.

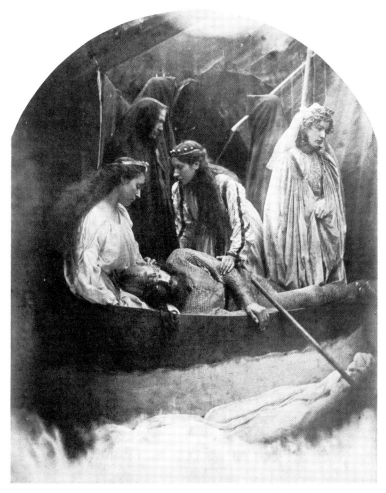

J. M. Cameron: *The Passing of Arthur*, The Idylls of the King, 1875.

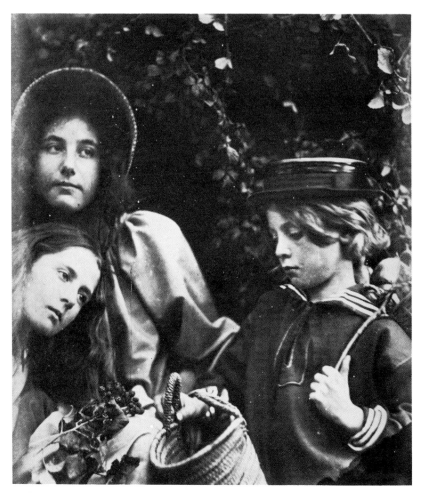

J. M. Cameron: *Blackberry Gathering*, c 1870.

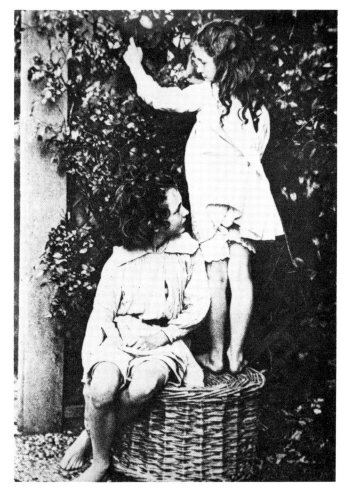

F. Myers: *The Summer Garden.*

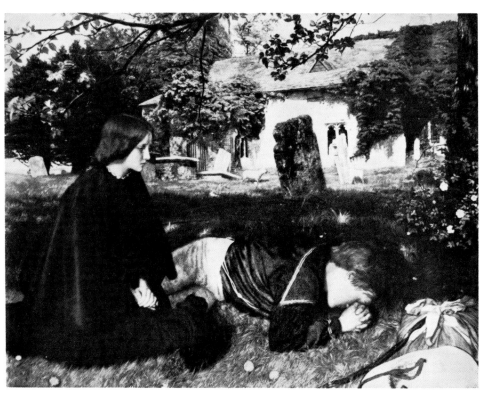

Arthur Hughes: *Home from the Sea*, oil 20 x 25¾ in., 1863. (The Ashmolean Museum)

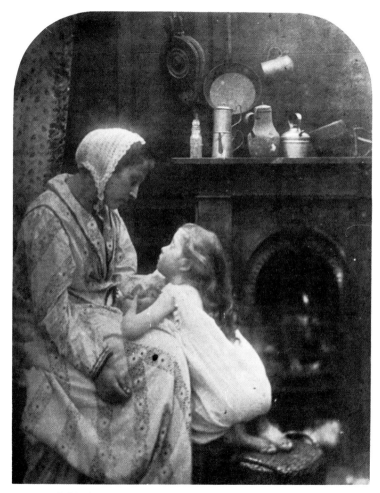

J. M. Cameron: *Pray God bring father safely Home*, 1872.

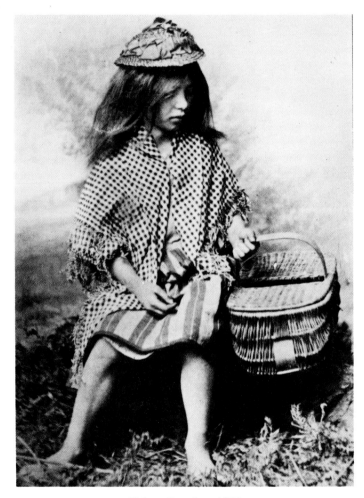

Robert Crawshay, 1876.

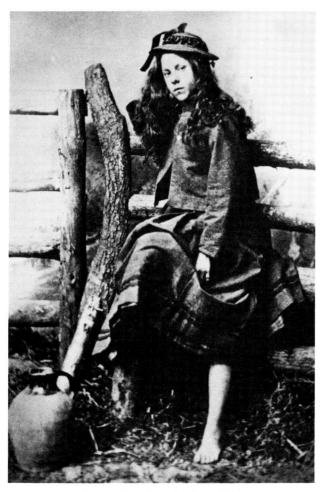

Robert Crawshay: October, 1874.

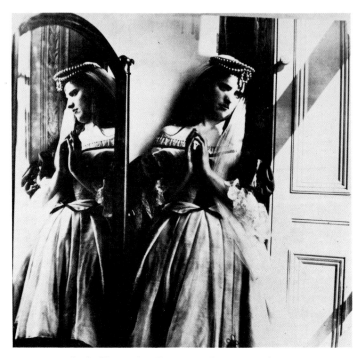

Lady Clementina Hawarden: Study with mirror.

Lady Hawarden's attitude towards costume and, in particular, the delicate 'niceness' of pose, give an oppressed sexuality to her subjects. The refined groupings of two women or a girl matched, Narcissus-like, with a mirror, when combined with her interest in contrasting patterns of shadow and light resulted in a languid, almost Sapphic sensuality. Indeed at times her work seems to hover on the knife edge of mannerism and pictorialism, but it is her knowing, careful manipulation of light, at times dissolving solid forms, which saves her from the sentimental excesses of Victorian high art photographers.

Although her work has often been linked to that of Julia Margaret Cameron, Clementina

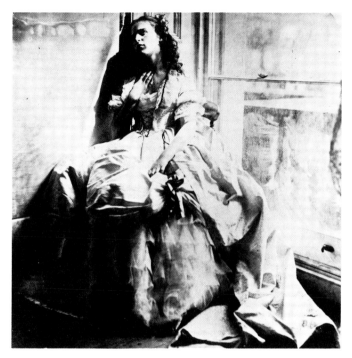

Lady Clementina Hawarden: Study.

Hawarden struck out into areas and depicted moods unknown to the art photographers of her age. Her vision of languidly tranquil ladies carefully dressed and posed in a symbolist light is at opposite poles from Mrs Cameron's images. There are also in her work elements of an acute romanticism, reminiscent of an earlier generation of artists, and some of her images recall the oeuvre of Caspar David Friedrich. But she remained quintessentially Victorian, even in the obsessively ambiguous sensuality which haunts so much of her era's art, and her work, in which there are remarkably few failures, constitutes a unique document within nineteenth century photography.

C. L. Dodgson: *The Dream*, The Barrie Children, c 1857.

INDEX